LIGHT
FOR
THE WORLD
TO
SEE

FOR WORLD TO SEE

KWAME ALEXANDER

HOUGHTON MIFFLIN HARCOURT
Boston New York

"American Bullet Points," "Take a Knee," and "The Undefeated" were originally performed for ESPN's theundefeated.com.

hmhbooks.com

Book design by Sindiso Nyoni

ISBN: 978-0-358-53941-4

Printed in the United States of America
DOC 10 9 8 7 6 5 4 3 2 1
4500811348

For **Kadir Nelson, Kevin Merida,** and **Nikki Giovanni,**
soul-sharers, light-bearers, truth-tellers

CON

This is precisely the time when artists go to work.
There is no time for despair, no place for self-pity,
no need for silence, no room for fear. We speak,
we write, we do language. That is how civilizations heal.

—Toni Morrison in *The Nation*

Freedom Now

In Brooklyn, New York, on the morning of November 7, 1978, as I got ready for school, my father, the principal, informed me that the entire student body would be marching over the Brooklyn Bridge into Manhattan to protest the police killing of Arthur Miller, a Crown Heights Black civic leader. My first reaction was fear.

I cried as my classmates and I shakily marched across the Hudson River, along narrow streets lined with supporters and policemen. Even though this was not my first racial justice–themed school "field trip," it was my first march across a bridge, and I did not want to suffer the same fate John Lewis and his fellow civil rights demonstrators did on the Edmund Pettus Bridge in 1965—attacked and bloodied by police officers. In my ten-year-old mind I was certain that if police officers who were sworn to serve and protect human beings could murder a civic leader—and be acquitted of all charges—then surely they wouldn't think twice about siccing their police dogs on us, or fire-hosing us, or worse, somehow managing to open up the bridge. While we were on it.

Among the marchers and protestors on that cloudy day were Jitu Weusi, founder of Uhuru Sasa Shule ("Freedom Now School" in Swahili), the progressive school I attended; Anna Quindlen, *New York Times* reporter; Sonia Sanchez, poet; and members of the congregation of the House of the Lord Church, whose pastor, Herbert Daughtry, was the protest's organizer and leader.

As the march entered Lower Manhattan and capstoned into a spirited rally, the reverend shouted atop a car, "We have not been satisfied that police are going to stop killing our children," and then he began to lead us in song . . . in a psalm of resistance: "We're fired up, we can't take no more. We're fired up, we can't take no more." As the chants grew louder, the rhythm stronger, a spiritual momentum gained, and I found myself joining the chorus of activists shouting triumphantly. The moment was contagious, akin to being in church and not realizing you're on your feet, clapping, making a joyful noise like everybody else . . . until you are. My angst cooled. I raised my huge placard with Miller's face on it and found my footing. I couldn't articulate what was happening at the time, but somehow, in that moment, I found comfort in my voice, in those around me who were lifting theirs. But it wasn't just comfort that the words and sounds brought me, it was also a kind of muscularity. A power to face the world and demand that it see me. The power to speak up about what mattered. Black lives.

Recently, as I've struggled to find my own meaningful way of parting these waters of racial injustice that threaten to drown us today, that have haunted us for centuries, I keep returning to

the words we chanted that day. And wondering, are they strong enough to carry this weight?

This book is me attempting to answer that question. Me lifting my voice, using my words to say something . . . about racism, about Black triumph, about solidarity. About police brutality and its devastating impact on Black America, on America. This book is a sort of wading into the water, a roll of thunder, a call to action. A rally in verse.

Audre Lorde wrote, "Poetry lays the foundations for a future of change, a bridge across our fears of what has never been before." We find ourselves in a world like never before. And, yet, we've always been here. In this moment, as we grapple with the fear, the uncertainty, the awakening, I turn to poetry, a small but powerful emotional geography that has the ability to reach inside of us, map our humanity, anchor us on solid ground, heal, and lift our souls to the heights of joy.

These three poems have been my balms. They are my chants, my psalms, my songs of protest. My hope for us is built on nothing less. We all want to be a part of the change that's happening in the world. So, yes, we are fired up, because we can't take no more. And we are coming for our freedom. Now.

Kwame Alexander

London, England
July 2020

I.

we can't see our home

we can't breathe the air

we can't break the chains

we can't run away

WE CAN'T KEEP OUR TONGUE
WE CAN'T LEARN TO READ

we can't be **in love**

we can't be a GROUP

WE CAN'T SHIELD OUR GIRLS

WECAN'TSAVEOURSONS

we can't hold our own

we can't bend a knee

we can't take a stand

WE CAN'T SAVE OURSELVES

we can't hold a gun

we can't stop that whip

we can't wear this skin

WE CAN'T HANG *OURSELVES*

we can't run
 we can't stay
we can't fight
 we can't last
we can't vote
 we can't voice
we can't whistle
 we can't breathe

we can't breathe.

WE CAN'T CROSS A BRIDGE
WE CAN'T RIDE A BUS

WE CAN'T BE IN CHURCH
WE CAN'T HAVE A DREAM

WE CAN'T WEAR OUR SKIN
WE CAN'T WEAR A HOOD
WE CAN'T PLAY OUR SONGS

WE CAN'T BE OURSELVES
WE CAN'T BE AT HOME
WE CAN'T BE ALONE

we can't be
unarmed
we can't shoot
ourselves

we can't hold a gun
we can't hold a toy
we can't hold a

phone

we can't do a thing

we can't drive a car
we can't walk the street
we can't ride a bike
we can't run away

we can't be

a boy

we can't be

a man

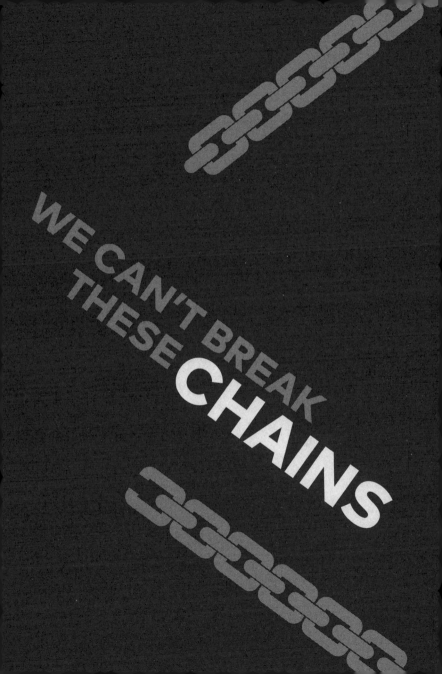

we can't walk
 we can't run
we can't breathe
 we can't live
we can't breathe
 we can't live
but . . .

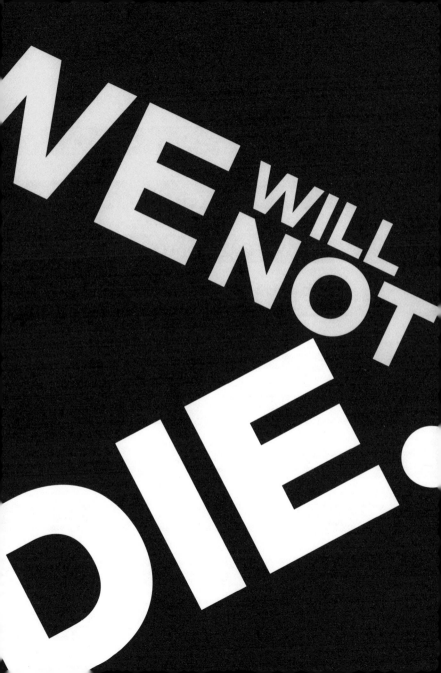

II.

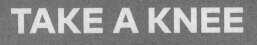

TAKE A MOMENT

TAKE A PICTURE

TAKE A BOY
TAKE A PARK
TAKE A TOY

TAKE A MAN
TAKE A GUN
TAKE A GUESS

TAKE A LOOK

TAKE A SHOT

TAKE A BULLET

TAKE A LIFE

TAKE A LIFE?

TAKE A LIFE!

TAKE **TAMIR**
TAKE **TRAYVON**
TAKE **CORNELIUS**
TAKE **PHILANDO**

TAKE **JAMAR**
TAKE **BREONNA**
TAKE **SANDRA**

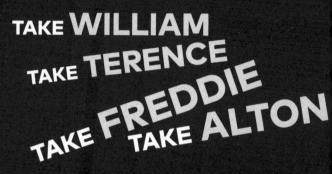

TAKE CHRISTIAN

TAKE KEITH

TAKE GEORGE

TAKE WALTER

Take a breath

TAKE OAKLAND

TAKE CLEVELAND
TAKE FERGUSON

TAKE SAVANNAH

TAKE TULSA

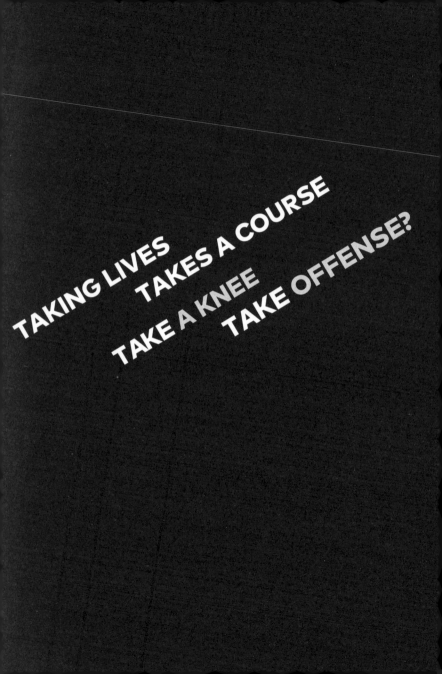

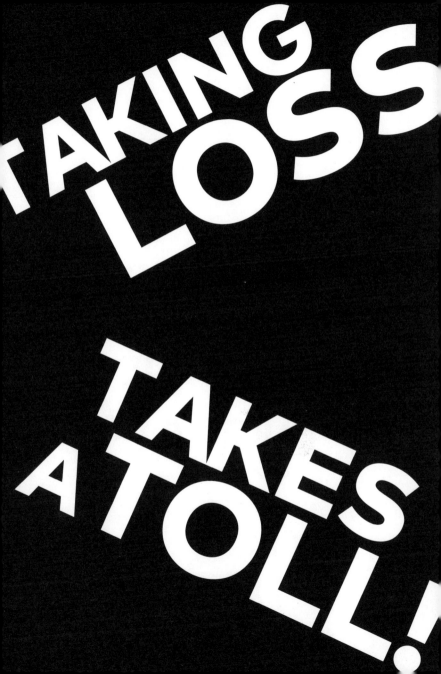

TAKING KNEES TAKES A LOAD TAKING STANDS TAKES A LOT

TAKE A **STAND**
TAKE MY **WORD**
TAKE **THE WORD**

**TAKING LIVES
TAKES YOUR
SOUL**

TAKES OUR
DREAMS
TAKES THEM
HOSTAGE

TAKES THEM OUT
TAKES US BACK

TAKE A STAND

TAKE THIS MOMENT

TAKE THIS FLAG
TAKE THIS DREAM
TAKE US FORWARD

TAKE THIS MOMENT
TAKE A PICTURE

TAKE THIS BOY

Take that
boy
Take that
woman

Take this
man
Take
You

Take Me

Take us all

NOW TAKE A SHOT
AT NOT GIVING UP

ON AMERICA.

III.

THE ★ ★ ★

UNDER

This is for the
unforgettable.

The swift and sweet ones
who hurdled history

and opened a world

of possible.

THE ONES WHO SURVIVED
AMERICA

BY ANY

MEANS
NECESSARY.

AND THE ONES WHO DIDN'T.

★

THIS IS FOR THE UNDENIABLE.

THE ONES WHO SCORED
WITH CHAINS
ON ONE HAND
AND FAITH
IN THE OTHER.

This is for the unflappable.

The sophisticated ones
who box adversity
and tackle vision

who shine

their *light for the world to see and don't stop 'til the break of dawn.*

THIS IS FOR
THE UNAFRAID.

THE AUDACIOUS
ONES
WHO CARRIED
THE RED,
WHITE,
AND
WEARY BLUES

+

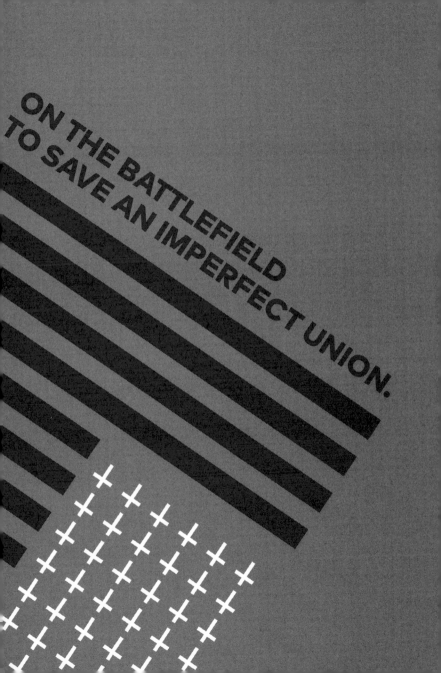

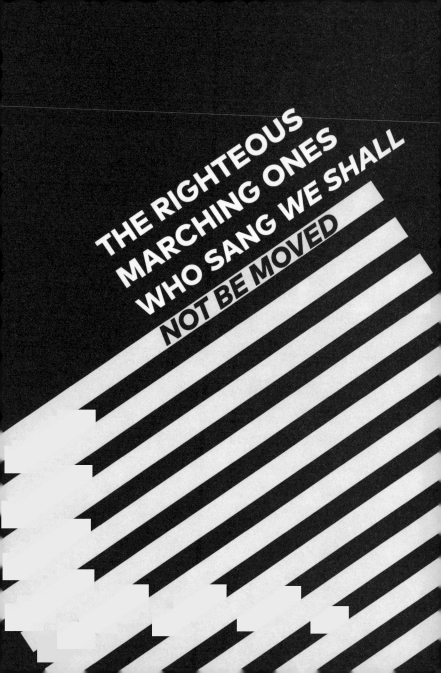

BECAUSE BLACK LIVES MATTER.

THIS IS FOR
THE UNSPEAKABLE.
THIS IS FOR THE
UNSPEAKABLE.
THIS IS FOR
THE UNSPEAKABLE

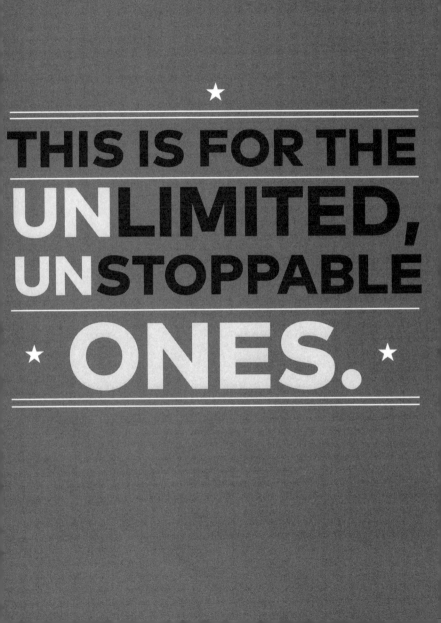

THIS IS FOR THE **UN**LIMITED, **UN**STOPPABLE ONES.

The dreamers
and doers
who swim
across *The Big Sea*
of our imagination

★

and show us
*the majestic shores
of the promised land.*

★

THIS IS
FOR THE
UNBELIEVABLE

THE
WE
REAL
COOL
ONES.

THIS IS
FOR THE
UNBENDING.

THE
BLACK AS
THE NIGHT IS
BEAUTIFUL
ONES.

This is for the underdogs
and the uncertain,
the Unspoken
but no longer untitled.

★

THIS IS FOR THE UNDEFEATED.

★ ★ ★ ★ ★ ★ ★ | ★ ★ ★ ★ ★ ★ ★

THIS IS FOR YOU.

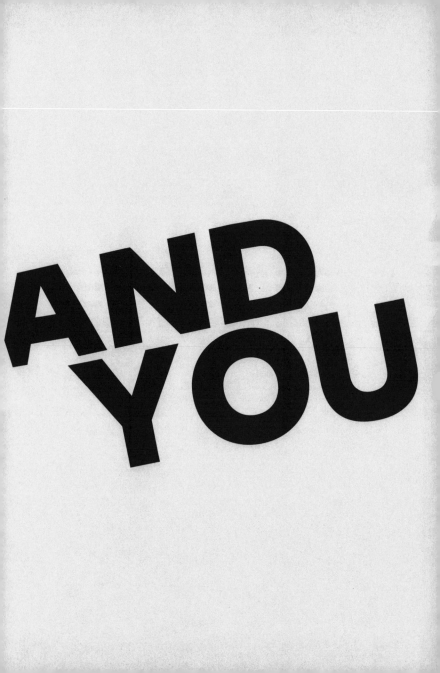

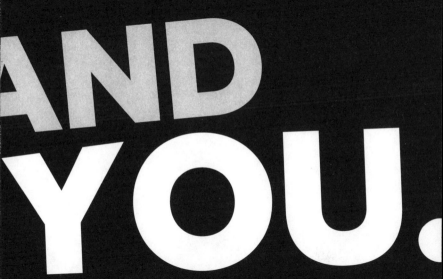

THIS IS FOR

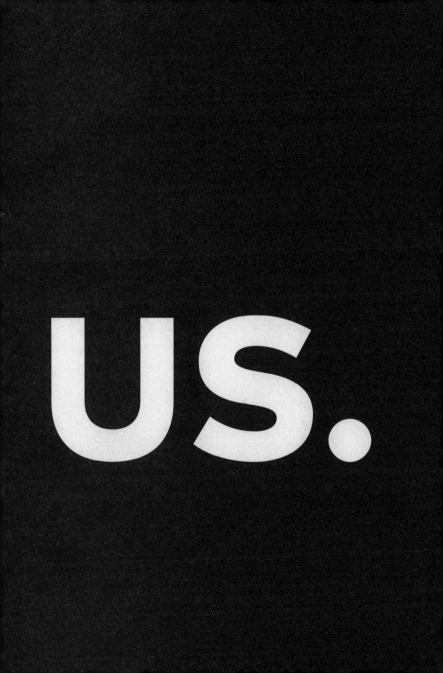

KWAME ALEXANDER

is the critically acclaimed, award-winning, *New York Times* best-selling poet and author of over thirty-five books. The organizer of the #Artists4BlackLives and #KidLit4BlackLives rallies, he is a regular contributor to NPR's *Morning Edition* and the founding editor of Versify, an imprint of Houghton Mifflin Harcourt.